Praise for

Rising in Glory:

I have known Dr. Giebink for many years and worked with him professionally. Once he sent me a copy of one of his poems, I recognized the beauty of his writing. I asked him if he had other poems and he gave me his manuscript. As I read through each poem, I was usually moved to tears. I told him about my books and asked if he was interested in publishing his work. He was too shy to think that anyone would want to read his poems. I told him that Jesus says in Matthew that we are the light of the world, the salt of the earth and it is our responsibility to share our strength, experience, and hope with anyone who will listen. Maybe God wanted him to share his poems. He was still reluctant, but I kept asking him if he had sent his manuscript to a publisher and he kept saying no. I emailed him a list of publishers of poems and finally he forwarded his work to you. I believe this; the world needs this book because many of us feel the same way. We feel too insignificant to do God's work, but the Bible is full of flawed people called by God to share his message.

—Robert R. Perkinson, Ph.D.

Reading Bob Giebink s reflections on his family in the Introduction to *Rising in Glory: Poems from a Freed Soul* provides an insight into his personal journey. Bob's parents, whom I knew, were exemplary people. His siblings, too, were influential in many lives; in my case, that was especially true of Bob's sister Jan.

Bob's poetry that follows reveals an outdoorsman, a healer (Bob is a psychiatrist), a man who loves his family and friends, and a man of deep faith. I recommend this book to anyone. You will benefit from reading it!

—Steven J. Bucklin, PhD Emeritus Professor, The University of South Dakota

This journey of raw faith is rich in thoughtfully woven poems that provide a window into an authentic and open soul. By exposing real-life struggles with vulnerability and compassion that will resonate with readers familiar with mental health struggles and addictions, this patchwork of poems delivers a renewal of hope that God is ever present and has great plans for each of us.

It is Dr. Giebink's own words that perhaps sum it up best, "…most of all, I enjoy standing firmly in my literary lighthouse, shining gospel beacon out to sea, over the land, far and wide to all the nations, to the ends of the earth crying, 'Jesus loves you, He will save you.'"

—**Steph Korver**, Chief Operating Officer of MWI Health

Being Bob's brother, I can attest to his early passion for literature and then writing. I also witnessed his surprising transition from partygoer to humble servant. One thing I like about Bob's poems and essays is his descriptive efficiency. He often uses the beauty of nature as a calming touchstone, as well as evidence of creation by a loving being.

My brother's writings may be a sort of self-therapy or form of praise, but they collectively express the basic tenets of Christianity that he would like to share with others who may be mired in fear and doubt. He wants to be his brother's keeper, and in my case, he literally has been.

—**Bradley Giebink**, BS, Geological Engineering, Found Object Sculptor

Bob is a sincere, compassionate person who values family and friends. His mother and father were role models, being gracious and generous using their time, talents and treasure to help people. When you spent time with the Giebinks, you were family, whether it was sailing, sledding, or eating the world's best ham sandwich.

Bob and I became friends in kindergarten Sunday school. He wandered at times early in his life journey, but his desire to help people is what got him where he is today. He has a deep and abiding faith that drives his passion for the Lord. An important way he expresses it is writing and sharing his poetry, and now he wants to share it with you!

—**Randy Stewart**, Master of Divinity, MBA

For years I have loved my brother's poems and prose. He captures and articulates loving the LORD with passion and humility.

His writing reminds me of the ONE who really matters above all else. It helps me to be steadfast, immovable... to "stand firm. Let nothing move you." (1 Corinthians 15:58 NKJV/NIV)

To be bold, to speak truth, and not be offended by the reactions of other people. Bravo Bob! So glad you are making these inspiring words available to benefit many more people.

—**Dr. Patti Giebink**, MD, Author of: *Unexpected Choice: an abortion doctor's journey to pro-life*

Rising In Glory

Poems from a Freed Soul

Written in gratitude
for Jesus Christ,
my Savior, Lord and Friend,
who gave me
the greatest gift of all,
His life

"…for to me, to live is Christ and to die is gain."
from the Apostle Paul,
an ambassador in chains,
to the Philippians (1:21 NIV)

Robert William Giebink

Published by KHARIS PUBLISHING, an imprint of
KHARIS MEDIA LLC.

ISBN-13: 978-1-63746-204-1
ISBN-10: 1-63746-204-2

Library of Congress Control Number: 2023930956

All KHARIS PUBLISHING products are available at
special quantity discounts for bulk purchase for sales
promotions, premiums, fund-raising, and educational
needs. For details, contact:

Kharis Media LLC
Tel: 1-479-599-8657
support@kharispublishing.com
www.kharispublishing.com

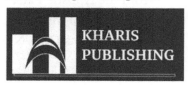

Dedicated to my daughter, Erin,
who has the heart and soul
of a poet, and to my grandson, Nolan,
who has the mind and spirit
of an engineer.

Contents

Introduction

"There are only two ways to live your life. One is as though nothing is a miracle. The other is as though everything is a Miracle...Only a life lived for others is worth living."
Albert Einstein

Thank you, Albert, for getting it right. I agree wholeheartedly, and I have known people who exemplified a life of service to others. I need look no farther than my own father and mother, born in December 1916 and June 1921, respectively. I haven't met anyone who worked harder and genuinely cared for people more than these two. They were perfectly matched partners. Being their son meant that they lavished their love on me and gave me every opportunity to enjoy life, see and learn about the world, and grow up to be a successful adult and responsible citizen.

My father, Robert Rodger, was the younger of two sons born to Henry and Johanna Giebink. He and his older brother, Gilbert Gordon, grew up in Orange City, Iowa. Dutch Country. Home to the Tulip Festival, and Northwestern, once a junior college, now a university. Bob attended Northwestern when it was a junior

college. One of his claims to fame was playing on the basketball team.

One Saturday, they played a game against the Harlem Globetrotters. Yes, one and the same, but the Globetrotters were not known so much for their antics then, as for being really slick, good basketball players. My dad was a good athlete, too, and played guard. He scored 16 points in that game, I recall him saying. He'd get guff from the crowd when he played in school games for putting up one-handed jump shots. Fans shouted, "Shoot with two hands. Shoot with two hands." Other players -- most if not all -- used the two-handed set shot. Dad was ahead of his time. He played a good game of golf, too, and aspired to be on the golf team in college, but life didn't lead him that way.

Being Dutch and living in the north country, it's not hard to imagine that my father was an accomplished ice skater. He had pairs of skates for figure skating and for speed skating. He and his friends would skate on the Floyd River, sometimes racing up and down the river. Girls were included in the fun, too. When he was older, my dad learned to snow ski, and taught both sports to his children.

My dad's life took a tragic turn at the age of 18 when his dad, Henry, died. The year was 1935 and Henry was 71. It has always amazed me that my dad's dad was born in 1863, in the middle of the Civil War. Henry had moved to Iowa from Waupon, Wisconsin, to be the superintendent of schools for the Alton school district. Orange City and Alton are separated by less than three

miles. Over the years, Henry became a successful investor and gentleman farmer. At one time, he owned a quarter interest in a small railroad. He owned 3,000 acres near Litchville, North Dakota, and owned the grain elevator in Litchville. Before that, he had a large hog consignment operation in Iowa and traveled to the stockyards in Sioux City to do business. My dad went with him to Sioux City, where he met twin sisters he knew as "Eppie" and "Popo." Their real names were Esther and Pauline Phillips. Each of them later took over advice columns started by other writers, and Eppie and Popo become known as Ann Landers and Dear Abby.

Henry traded in the stock market. Because he was diversified, he didn't lose as much or nearly lose everything the way many investors did from the stock market crash in October of 1929. But the Crash also marked the start of the Great Depression, soon followed by the Dust Bowl. Hard times turned doubly hard in the country's Heartland from the cruelty and randomness of weather pattern changes. One thing is certain: Henry had made his indelible impression on the lives of his two sons.

One consequence of Henry's death was that my dad followed his brother Gil to the University of Iowa in Iowa City, and even took classes in pre-law. Brother Gil was destined to become a corporate attorney and later a law professor. Gil transferred to the University of Minnesota to go to law school. My dad followed him to Minneapolis and pledged to the same fraternity. He

even went to law school for a year before deciding that studying law wasn't for him; it was too dry. One day, he picked up a frat brother's biology textbook and started reading it. Excitement filled him, a new world opened up, and he had a vision of his future. He'd take pre-med, go to medical school and become a doctor!

In Minneapolis, he met my mother at a fraternity-sorority dance. She was dating one of his frat brothers, but it was nothing serious. Dad was smitten and she was swept off her feet. A romance that would last nearly 65 years began, one that survived separation by the second global war and the deaths of so many schoolmates and close friends. Their love endured day-to-day struggles and heartbreaking losses besides the horrors of WWII. They celebrated ordinary and extraordinary triumphs and were blessed as only grace-filled lives can be blessed.

My dad was a captain in the Army Medical Corps during World War II. He was a physician by then. He was stationed in a small town in England north of London for six months prior to the Allied invasion of Normandy on D-Day, June 6, 1944. His unit crossed the Channel one week later and he remained in Europe until just after the end of the war. He was positioned near the front lines much of the time. He was awarded a purple heart, a bronze star medal for valor, and a bronze oak leaf cluster, the equivalent of a second bronze star medal for valor.

My mother, Mary Elizabeth, was the younger of two daughters born to Conrad and Adele Seitz. She and her

older sister, Carole, grew up in Minneapolis, Minnesota, "City of Lakes" in the "Land of 10,000 Lakes," and one of the Twin Cities, the other being the state capital, Saint Paul, to the east. The Seitz family lived not far from the main campus of the University of Minnesota, where Conrad was employed for 50 years, the last 25 as bursar, or treasurer, of the University.

Mom told me once that her family was little affected by the Great Depression. She said she didn't notice or pay much attention to it. Although Grandfather Conrad was very strict in some ways, such as table manners, he offered opportunities to his daughters that were exceptional. My mom was one of the first women in the Twin Cities to earn her pilot's license and fly solo.

The Minneapolis Tribune had a full page photo of Mom standing in front of a small plane, both arms raised, with her hands holding the left end of the propeller blade, her right leg extended to balance herself, poised to pull down the propeller to start the plane's engine. She was smiling, wind blowing in her hair. She was the picture of health and beauty, ready to fly that plane high into the air.

My mom bravely faced many challenges in her life and an early one was contracting the poliovirus. This damaged the motor neurons in her spinal cord, a result that affected only a small percentage of people who caught the virus, despite the illness being so widespread. Consequently, the muscles in my mom's

legs were affected, but she was able to rehabilitate and regain use of her legs; it was a life-shaping experience.

According to the Mayo Clinic, polio epidemics occurred in the US and around the globe through the 20th Century, including the widespread outbreak in the 1920s (when FDR contracted the disease) and disabled as many as 16,000 children in the US each year. Infection from the virus can cause temporary or permanent paralysis of the limbs and can even be fatal. Other outbreaks occurred between 1948 and 1955, when the first effective vaccine was developed, licensed, and distributed.

To say my mom was an attractive and desirable young woman is an understatement. Once, she told me how many times young men had proposed to her, and I took her to mean that these were serious proposals. It wasn't long after meeting my dad that he proposed to my mom, she accepted, and they were married. To say they made a handsome couple is likewise an understatement. Their marriage was as close as any to being a match made in heaven.

They honeymooned in Acapulco. My father was a strong swimmer and enjoyed diving, so he joined the local men diving off the cliffs. My mom enjoyed telling a humorous story of how she and my dad met a wealthy young Mexican in Acapulco, who befriended them, wined and dined them, and invited them to his penthouse. There they were able to sunbathe *au naturel* in complete privacy.

It was Dad's work on the battlefield and in field hospitals that gave him his interest in the very young specialty of orthopedics. When he returned to the United States, he trained in orthopedics and began his practice working for the Department of Veterans Affairs. He and nine other specialty physicians, all World War II veterans who had been working at the Veterans Hospital, joined together to found the St. Louis Park Medical Center in St. Louis Park, Minnesota. It was and still is located not far to the west and north of Lake Harriet, and just a little farther west and north from where my mom and Aunt Carole grew up in old Minneapolis.

No matter how hard he worked or where his work took him, Dad's family was always a priority. He found time to be involved in his children's lives. He wanted to find out what and how they were doing. It was easier for him to participate in activities with his three younger children, with a six-year gap between them and the four older children.

My two younger brothers and I were born in Sioux Falls. Our dad was looking to establish his private practice and further his career when he and my mom decided to move and settle here in 1953. At the beginning, he was able to work half-time at the new Veterans Hospital in Sioux Falls. He continued working for the VA part-time for 16 years.

The St. Louis Park Medical Center opened on July 2, 1951. Two years later, my dad sold his interest in the business and had the financial wherewithal to strike out

on his own. He built his own clinic in Sioux Falls near Sioux Valley Hospital, the hospital where his youngest three children were born, where my three children were born, and where my two grandchildren were born.

Words are at the center of what we writers do. Each word we choose to use is important. The word "orthopedic" is from the Greek; "ortho" means "straight," and "pedic" means "child," so orthopedic means "straight child." When I was in ninth grade, I interviewed my father as part of an assignment for a unit on career exploration. He was 39 when I was born, less than four months from turning 40. That would make his age 53 or 54 at the time of the interview. I asked him what had been the most rewarding or fulfilling time, so far, in his medical career. He said it was during the polio epidemic. He was able to use all of his medical skills and experience to literally straighten children and help them regain use of their limbs.

Which brings me back to my mom. She and my father built their dream house on a bluff overlooking the Big Sioux River. It was set on 23 acres. We moved there in January of 1963, the middle of second grade for me. The house had stairs designed to make it easier and safer for my mom to go up and down them.

My parent's bedroom was upstairs and the kids' bedrooms were downstairs. The house was built into a hill and even had a bomb shelter, since it was the height of the Cold War. The house had two utility rooms with laundry machines so Mom didn't have to go up and

down the stairs with laundry. Besides her mobility challenges, my mother had corns on her feet that were painful, so she wore special shoes for her daily use.

Our house was big for when it was built, 4,800 square feet. It had comfortable living areas upstairs and downstairs. The dining area off the kitchen was large enough for a custom-made round table for the nine of us that had a lazy Susan turntable in the middle, a smaller matching round table that fit four chairs, space to have two designer chairs with footstools and a TV set on a stand. Along the wall opposite the dining table was a low set of built-in drawers and shelves with a place for a desk chair in the middle where we could sit to write and draw. The area was a third, well-used living space.

It didn't matter. We three younger kids spent a lot of our time in the evenings in our parents' bedroom, watching TV with them on their California king-size bed. There also were reclining chairs in the corners of their room and a fireplace, one of three in the house. It felt cozy and safe. Even in high school, or during our college years, it was okay to lie on their bed and watch TV with them or just talk. Sometimes the door was closed, but I'd knock anyway and be invited to enter. We were always welcome.

My dad was an accomplished surgeon. He kept a black medical bag at home with supplies for his own use. I remember more than one time observing him sitting at the foot of the bed on my mom's side, scalpel in hand, paring cornified tissue from my mother's feet.

Then, he'd use a file to smooth the surfaces. This eased the pain she had when she walked. He did it with such care and precision. The procedure itself caused pain. He was very attentive to what my mom was saying or how she was reacting. It was just one example of their love in action, pure and simple.

My mom was a wonderful cook, loved to cook for our family, and found great pleasure in preparing and serving delicious meals. She'd wait to sit and eat until all of us were served and eating. She'd pop up and go to the kitchen if any of us needed anything or wanted second helpings. She'd feed anyone who happened to stop by, whether it was at our house in Sioux Falls or our summer place at Lake Okoboji, Iowa. My dad was genuinely grateful and complimented her on the marvelous food. He was sure to praise her. Her cooking and serving food to him and others was another example of love in action, pure and simple.

The oldest of my siblings was Mary Janice, whom we called Jan. She was born in November 1943. My dad was preparing to leave the United States to travel to England with his unit, so he couldn't be there for the birth. Back then, it was common for women in labor in the hospital to receive general anesthesia, and delivery included the use of forceps. This is what happened with my mom and Jan. There was some question whether Jan got enough oxygen during the procedure. She is developmentally disabled. Later, she met the criteria for having moderate mental retardation. Based on some of her physical features, it is possible she has

a genetic mutation and was not oxygen deprived at birth. She was never tested for this. She is as healthy as any of us and it wasn't important. Jan was loved as much as any of us. Adored, I'm sure.

She had special needs and my parents did everything they could to see her needs were met. One of the reasons they decided to relocate to Sioux Falls was because Jan would be able to attend Hollister School, a day school for people with disabilities. Classes were held in an addition Mrs. Hollister built onto her house. When our family took trips, Jan sometimes stayed with Mrs. Vickerman, a teacher at the school.

At Hollister, Jan learned numbers, the alphabet, and how to copy words. She learned to play simple card games and put puzzles together. Perhaps more importantly, she was able to communicate and socialize with her peers. The staff and children respected one another. It was a haven, a place to be away from home and away from the cruel behaviors of people who didn't understand or didn't care about people like Jan who were different and had special needs.

When Hollister closed, my mom and dad and other parents helped establish a sheltered workshop at the old air base in Sioux Falls. It was a place for Jan and others to continue their education and training and learn skills to become productive members of the community. My dad then led a campaign to build Sioux Vocational School and Workshop for the Handicapped, which is now a part of Lifescape. He donated the land and the first $20,000 toward the project. He was on the

board for many years. At the age of 79, Jan still attends the workshop.

I could go on, but my dad wasn't seeking recognition for himself or to elevate himself in some hierarchy of earthly success. He served on several boards and was instrumental in initiating other projects comparable to Sioux Vocational. His life was the essence of philanthropy, loving mankind. He expressed it every day in many ways on many levels with people he encountered. As a physician, he said he tried to do three things: Be honest, be caring, and be cheerful. That he was. And humble.

My mom was with him all the way. They both had a great sense of humor. My mom almost always had a "funny" for the day, something she had read or heard about, had maybe seen on the news, or it was something that had happened to her or someone she knew. Her "funny" was always amusing, never mean or inappropriate. And she told jokes, but only "clean" jokes, and they were invariably funny, as well. She was a sunshiny person. She had a way of answering the phone, "Hel-lo," with her voice rising then going down in pitch, and she'd stretch the word out when she said it. It sounded friendly, almost musical.

My dad was gifted musically. He loved to sing and sometimes sang in the church choir. Sometimes, in the summer, he sang at the piano bar at the Inn at Lake Okoboji when they had their weekly singalong. Sad to say, I take after my mom musically. Just like her, I make a joyful noise when I sing.

But sing my mother did, at night when she was putting me and my two younger brothers to bed when we lived at our first house in Sioux Falls. We shared a bedroom. She had two songs she sang, and as I remember, she sang them beautifully:

"Now I lay me down to sleep, angels watching over me, my Lord, I pray the Lord my soul to keep, angels watching over me.

All night, all day, angels watching over me, my Lord, all night, all day, angels watching over me.

If I should die before I wake, angels watching over me, my Lord, I pray the Lord my soul to take, angels watching over me.

All night, all day, angels watching over me, my Lord, all night, all day, angels watching over me."

And she sang:

"Three little angels, all dressed in white,
trying to get to heaven on the end of a kite.
The kite string broke and down they fell,
instead of going to heaven, they went to
Three little devils, all dressed in red,
trying to get to heaven on the end of a thread.
The thread it broke and down they fell,
instead of going to heaven, they went to bed!"

My mom did make sure we kids went to Sunday School when we lived in our first house in Sioux Falls. It was only five blocks from First Baptist Church. We resisted going to Sunday School. As we got older, after we moved and it was farther away, it became easier to convince our mom not to go. Later, when I was in

junior high and high school, I enjoyed going to worship services with my dad. I especially enjoyed listening to Pastor Roger Fredrickson deliver his sermon, God's message. As I said, my dad liked singing, and he liked to socialize, but I wasn't real regular about going.

Both my parents had pet names for me. My mom's pet name was "Rubble-Bubble Double-Trouble." She'd use it when she was happy and feeling good and being affectionate toward me. Usually, it was just the two of us. It was one way of loving on me. I think she liked saying it, and it is fun to say. I liked hearing it. My Dad's pet name was Robin, which happens to be one of my two favorite birds, the other being the cardinal, my mom's favorite bird. With the first name of Robert, Robin was a fitting nickname. My dad used it now and then for my whole life while he was alive, and I liked hearing it. He was loving on me.

I got a lot of that from my mom and dad and from other moms and dads in the neighborhoods where I grew up. I was blessed, abundantly blessed.

In memory and honor of Bob and Mary, a poem:

Proof of Love

Trust and commitment,
plus faith,
equals two standing before the Cross
as one,
vowing I do, promising we will
Amen

Part 1
The Call

A Profound Truth

The reason to protect
and preserve earth,
nature,
creation,
is not
for its own sake,
or even for ourselves,
or our children,
or their children

No,
though we are called to be good stewards,
caretakers,
protectors,
preservationists
See Owners' manual, Bible,
instructions God gave Adam in Genesis,
even before He gave Adam Eve
The Lord God took the man
and put him in the Garden of Eden
to work it and take care of it

It's profound
when you know this to be true
with every fiber of your being,
when you believe it with all your heart,
when you bow down daily

to worship God the Creator,
when you live for Him,
love Him,
trust Him,
obey Him, and
when you then pass it on

Might be Today

Remember joy and easy laughter?
Think back, I know you can,
to when you were the perfect woman
and I the perfect man?

We walked out in the garden,
boldly and unashamed
Our Father fed us daily
and called us each by name

We came upon a fruited tree,
oh, horrible, fateful day!
The serpent tempted and we ate,
in terror turned and ran away

Ever since, I keep on searching
for my God, myself, and you
Just when I think I've found us,
I find again I've played the fool

But my Father keeps His promises
We'll meet in New Jerusalem
All will be well between us
in that glorious day just ahead

A New Heaven and a New Earth

Revelation 21:1-4 NIV

1 Then I saw a new heaven and a new earth, for the first heaven and the first earth had passed away, and there was no longer any sea.

2 I saw the Holy City, the new Jerusalem, coming down out of heaven from God, prepared as a bride beautifully dressed for her husband.

3 And I heard a loud voice from the throne saying, "Look! God's dwelling place is now among the people, and he will dwell with them. They will be his people, and God himself will be with them and be their God.

4 'He will wipe every tear from their eyes. There will be no more death' or mourning or crying or pain, for the old order of things has passed away."

Newcomer

Welcome, all are welcome
to be with me here on this day
It is a glorious day,
a day the Lord has made
I rejoice and am glad in it

I sit here on the deck in this painted yellow
metal chair with my cup of black coffee
looking at the backyard,
feeling more than blessed,
feeling utterly alive

My view is filled with flowers my daughter
has carefully selected and cared for,
planted in an assortment of pots,
an eyeful of colorful blooms,
her passion, mine to enjoy

Always I listen for sounds
of life surrounding me,
the buzzing of a nearby bee,
chatter of squirrels in a tree,
or loud sawing of cicadas

Ah, the music of birdsong
Many I hear and know instantly,
a cardinal, robin or chickadee,

a purple finch, goldfinch or grackle,
a bluejay or mourning dove

I observe them in flight,
another way to identify,
the robin's familiar rapid flap
and glide, the dove's darting,
erratic and swift motion

It's the first days of August
Summer days blaze, nights begin to cool
Soon the trees will display
the signs of first-turning color
in their homage to fall

All too soon, fall will come,
another season of glory,
when leaves go toward
the red end of the spectrum,
only to wither and fall

Then the wind and cold
set in, and migration begins
Geese wing their way south
Other birds appear, flock,
then seemingly disappear

The sun fails to rise as high
in the sky or stay as long
Night eats away at the day

My mood follows in synchrony
as fall gives way to winter's sway

And yes, mornings of sitting on the deck,
cup of coffee in hand, are long gone,
as are my song-filled feathery friends,
except the hardy few who rarely come in view

Ah, but hope indeed springs eternal,
and for me it is not only the beckoning spring,
but the promise of something much greater,
life abundant, life eternal, from which hope springs

Of Salt and Light

and time, and connecting them
Energy equals mass times
the speed of light squared
It may seem simple, but isn't
Light has properties
of waves and particles,
Time slows down, speeds up

The universe is expanding
Now we see billions of galaxies
Black holes, gravity so strong
even light can't escape
We're told "dark" energy and matter
are greater than all other
Interstellar space is not void, after all

String theory, theory after theory,
Each grows more fabulous, more mystical
DNA, the language of God, yes
Big Bang, God speaks the
universe into existence
Being in time, out of time,
before, after time

Try Truth on for size,
the Creator of the universe
made flesh to die for you

No greater love has a man than this,
that he lay down his life for his friends
"I go to prepare a place for you,
so that where I am, you may also be."

Beacon

Sometimes in life, I ride a mighty high horse
I have fallen off a horse, fractured bones,
been knocked unconscious, experienced
exquisite pain that made me physically ill

I've had several knocks on the head
over the years, when I was knocked out
You'd think it would've knocked some sense
into me, and not just knocked me senseless

Now and then, I am tempted to sail again
after years of dreaming all winter long,
forgetting I overturned my sailboat in a squall,
hanging on for dear life, and very nearly drowning

I've tipped over sailboats several times
As a young man, I enjoyed
sailing in heavy winds and rough weather
while more-seasoned sailors stayed on shore

Now I'm seasoned, a self-avowed landlubber,
not that I won't venture forth onto
inland lakes or plunge into ocean waters,
as long as *terra firma* is close at hand

In time I became a fair-weather sailor,
still enjoying a brisk, steady breeze,

And though I tamed fear and mounted
a horse again, I rode only a handful of times

Nothing appeals to me more than the idea
of lounging on a tropical beach, sitting in the shade
of a palm tree, sand set ablaze by the sun,
then a dash into the surf for a swim

Most of all, I enjoy standing firmly in my
literary lighthouse, shining the gospel beacon
out to sea, over the land, far and wide
to all the nations, to the ends of the earth,
crying, "Jesus loves you, He will save you."

Change

Is it time for you to begin?
Jesus the Christ saying to Nicodemus the Pharisee,
"You must be born again."

Paul the Apostle writing to the Ephesians,
early Gentile Christians,
"Put on the new self."

More of Jesus according to John, the one He loved,
"I am the door, if anyone enters through me,
he shall be saved."
And from Matthew,
a tax collector despised by Jews and Romans alike,
but not by Jesus,
"Knock and it shall be opened to you."

From John again,
"I am the Way, the Truth, the Life.
No one comes to the Father but through me."
And from Paul,
"All have sinned and fall short of the glory of God."

People, wake up!
What are you waiting for?
A miracle?
Then ask for one in faith, humility, complete surrender,
and Jesus will come into your heart, into your life

He will surely change you from the inside out
Yes, He will

The Race

Scurrying from shadow to shadow,
avoiding light, seeking deeper recesses of darkness,
citizen of the world, one among billions,
running the race of madness and death,
running the race that can't be won

Lost, losing ground, time, heart, soul,
never finding joy, love, peace, hope,
only spreading anger, hatred, pain, despair,
never to see the face of the Almighty,
or to know infinite grace and mercy

I quit that race to run another,
a race already won, though just begun
Fixing my eyes on Jesus, reflecting
His light, climbing ever higher
with Him to realms of glory

The victory is His,
will you join me?

Poison

Launching ships armed and loaded
with anger and blame,
yet harboring vessels
heavy-laden
with guilt and shame,
the first to do battle
with foe or friend,
the second to shelter
the enemy within

Enough!
Call a truce!
Seek the Truth!
I say sin is poison

Let go your hatred
Release your burden
Shackle the fiend
Embrace the Friend

To know, to receive love and forgiveness,
you must ask
To honor, to serve your Lord and King,
you must give
love and forgiveness, and give up sin

Choices

Great terrible waves came,
crashed down on me, pounded me
Finally, they receded,
taking with them the emptiness
and fearful darkness
that had invaded my soul

Replaced by kindly, gentle waves
like a dolphin leaping,
making a happy splash,
the sparkling surf rising,
rolling along the sandy shore,
the weather fair, breezes mild

Still, the sorrow lingers
It builds like ocean tides,
water rising from the pull
of an ever-circling moon
in a planetary dance
with a more powerful partner

Worldly sorrow is like that
It grabs hold of you,
tugging on you
It has its own gravity,
gripping with greater force,
until you slip below the surface

We all have choices to make,
choices we have made in the past,
dreadful, ugly choices,
now that we see them in
the light of Truth and the Son,
our bright Morning Star.

Know we can choose
to stay in the Light of the Son,
turn away from the death
of dark selfishness,
put on His righteousness,
and live forevermore

Amen

A Taste of Hell

Saw a chart once,
most addictive substances,
at the top, just above cocaine
and methamphetamine,
nicotine

I know all about it now
Studied it in pharmacology,
its effects on the central and
peripheral nervous systems

Began using much earlier,
making resolutions to quit
even while in high school
Couldn't quit, hooked but good

I tried many substances
along the way I was
even hooked on some,
but got off, eventually

I still crave a smoke
from time to time
Might go years,
give in, smoke one
A million reasons,
just like alcohol

Hooked again
"One is too many,
a thousand never enough,"
just like alcohol
Only harder to quit
for me, anyway
"Done it a hundred times."

Damn! Look at that burning
stick of tobacco
Call it by name
Satan!
Might just as well be
evil, ugly thing

Feeling
ashamed
guilty
angry

Hate it
Hate myself
Hate using
Hate quitting

Symbolic of larger struggle
with flesh, world, Satan

Helpless,
no control
Give up control
Call upon God

Help me, Father
Help me, Spirit
Help me, Jesus

I'm sorry
Please forgive me

What it takes
to begin anew
I surrender, Lord
to You

Not Too Late

Agony compounded
Dreams and desires confounded
Constantly fretting, yet knowing
it leads only to evil doing

Easy prey for the enemy

There is a deadness in life,
a realization of strife
Turning away from Lifegiver,
becoming thief and liar

Murderer and destroyer

That's where the dark path leads,
thoughts the same as the deed
Now carrying out the plan,
following it to a dreadful end

God will not be mocked

Only lift up your face
His grace is great,
greater than any sin
He will always take you in

Love overcomes hate

Amen

Boxed In

Oh! I'm a wild one,
a terrible, lawless streak
running through me
Marked from before birth,
I represent a reckless breed

Warily, I keep my eye
toward you
the pursuer, the tracker,
my would-be captor
But I can be distracted

In fact, I easily, often am
Then I turn my attention
away from you
and you always
let me have my head

Sometimes I gallop away,
startled into a stampede,
or trot away,
off on an escapade before
drifting your way again

You call to me, whispering
You know my name
You know everything

about me, where I've
been, where I'm going

You intrigue, frighten me
Attracted by your majesty,
trembling in awe,
I yearn to draw near,
to accept power, mastery

but I know harsh, cruel
reality of a haphazard life,
have suffered indignities,
sidestepped snares,
received, inflicted wounds

Yet you keep to the trail
Tirelessly, relentlessly,
you stay true as
the gap between us
widens, narrows

Days, nights
months, years go by

Until, at last, I stop
My chest heaves
My heart pounds
My body is spent
My spirit is broken

I am boxed in,
nowhere left to turn
but to you
corralled, held captive
by your love
and set free
forever

Heart Collector

When did the first crack appear?
It happened not so long ago
I don't have an answer
It's not so important, now, to know
I know all about infatuation, getting lost
in a flood of lust,
mounting fears and frustrations, finding release
a seeming must
Worldly passion turned to sorrow,
wounded pride, seething soul,
acting like there's no tomorrow,
following death's teeming road

Now I know the fruit of the Spirit, but how shall
I be known?
to some still trapped in aging flesh, only by early seeds
I've sown
But You know my heart and every crack put in it,
You even know the moment it broke
and You came to live within it
So I have faith and hope and peace,
and the Love that never fails,
knowing someday I'll see the One
who bled and died to make me well
Take my heart, Lord, it belongs to you

Turning, Returning

Hard truths painfully learned and costly
Illumination is slow, like a candle flickering,
then shedding light in a cavernous space,
darkness surrounding, confounding me

Truth is revealed to those who choose
Light, choose Life, yet so many
live in the shadows or wander with
good intentions, not knowing Goodness

As a young child, I met the Good Shepherd
I knew when I died, I'd go to Heaven,
see God, the Enemy only a vague
impression, an unnamed fear, then

TV was black and white, technology simpler
Life was simpler I watched Leave it to Beaver
My hero was Zorro My mom stayed home,
worked really hard, raised seven kids

It was the lull between wars, before our
deep involvement in faraway Vietnam,
brought to us on TV in living, dying color
It sparked great anger and protest

It coincided with many movements,
causes, upheavals It brought us drugs,
free love, civil rights, its music commenting,

inspiring, sounding the alarm

I was swept up in all of it, a little too young
to be drafted, too far removed
from the turmoil to actively participate,
a casualty of the times nonetheless

Of the drugs, the free love,
the false hopes, the dying dreams,
foolishly trying to walk the Christian way
and wanting others to do the same

How well I know, now, who the ruler
of this world is, Jesus said it himself
Although the Enemy, sin and death are defeated,
we still live in a world, fallen

Now's always a good time to turn away
from deadly deception, turn toward the
Light of freedom, open the door
of Salvation, embrace the Lord of Love

Return now to the Home you fled,
into the Father's arms, holding you close
now placing robe over your shoulders
ring onto your finger, restoring lost honor

you are His again
you are Home again

Amen

His Name is Love

His blood he shed on Calvary,
the blood that washes over me,
cleanses me,
makes me white as snow
'tis my Savior's blood, the Lamb of God
who takes away the sins of the world,
covering me, saving me, this I know

His Name is Love

His body He gave upon that tree,
the body broken just for me,
for my sin, my failure, my frailty,
'tis my Lord's body,
the body of Christ risen from the grave,
giving hope and light and life eternally

I need His love
I need communion with Him,
my Lord and King,
my Savior and Friend
I need His body and blood,
to taste the Word,
be Spirit-filled

I need the Bread of Life,
Living Water, Way to the Father

His Name is Jesus

My Cross

I lift easily, bear gladly in joy of following
You, oh Lord; once heavy, crushing down on me
now light in comparison
I knelt before You, laid my burdens upon You
You lifted me up, You took the weight
of my crippling sin

I learned at great cost, great injury,
great sacrifice that I could never
be good enough, work hard enough
or ever pay back what I had done
to others, and more importantly
to You, my Savior, my Friend

Every day from the moment I awaken,
I wrestle Old Man for stranglehold
I enter the World pulsating around me
full of color, sound, sweet intoxication
I encounter Satan, the Great Liar
and Destroyer, trying to seduce me

Help me, Jesus

I long for the day when I kneel again,
place my crown at your feet
and stand again to see You,
embrace You face to face
You are the Lover of my soul
my King, my everything

Light of the World

When I awaken each day, the battle begins
Death! to angry man
Slowly, little by little, his defenses weaken
With every foray, I feel my joy grow stronger,
my peace multiply, hope well up within me,
and love exceed all bounds

It wasn't always this way It was more like torture at
first, angry man guarding my heart, roaming in cover
of dark to prey on my helpless mind
You were the enemy then,
You were the keeper of Light that threatened to expose
my violent thoughts, my unholy urges

According to Paul, a saint is simply a forgiven sinner,
and that's what I am now, a sinner, forgiven of sin
and freed from deadly guilt
Now I, too, am a bearer of Light,
a witness to the Word, holding my lamp high,
proclaiming the power of the Blood
to cover and blot out sin

Rejoice in the Lord, always! Again I will say, rejoice!
and the peace of God shall guard your hearts and
minds in Jesus, the Christ, Messiah, Lamb of God,
Atoning One

The Lord is near
He is

Steady in the Lord

My Friend's hand
on the tiller
gently steering,
guiding our way

The favorable Wind
blowing, filling
our sails,
sending up spray

The Navigator
searching the sky,
plotting our course,
leading us home

Steady as she goes

My Friend sings
and laughs, speaks
words of great
wisdom and joy

His face shines,
eyes sparkle
with the light
of sun and stars

He invites me
to join Him
at the helm,
secure in His arms

and His love

Steady as she goes

Thorn

in my flesh is my flesh

Fallen Adam
sin nature
exciting wickedness,
stubbornly seeking
selfish pleasure,
only finding
sorrow of the world,
death

Risen Adam
sin offering
admitting weakness,
joyfully surrendering
grace sufficient,
then finding
power of Living Word,
life

"I desire compassion.
Love as I have loved.
Forgive your enemy.
Go and sin no more."

I will strive daily

to put off my old self,
to celebrate my weakness,
to pray in the Spirit,
to be unstained by the world

to ask for mercy,
to receive, to know
His love and forgiveness

to grow in faith,
to speak and to share
His peace and promise

Amen

The Chief of Sinners

I stray, when I would stay
I go from the perfect light
to the dead of night

My world shrinks from the infinite
and dazzling beauty of the universe
to a self-created cave, or a tomb,
while I seek to please myself

I turn my back on you, and yes,
I willfully separate myself from you
but I know no sin is hidden,
even the dark is light to you

Jesus, you witness and enter
my sin, my pain, my grief
I hate what I do more and more
but I do not hate myself anymore

Jesus, you love me
Jesus, you walk with me
Jesus, you forgive me
Jesus, you heal me

Amen

My Prayer

Please, Lord, I ask you
in your will and in your name

Purify my heart, sweeten my spirit, cleanse my mind
Make my life one of worship, daily prayer,
humble service

Fill me with strength of your joy, songs praising you,
true thanksgiving

Give me great love for you and for my neighbor
as myself

Please allow me, Father, to follow your son, Jesus
May I know, show, mercy, grace, forgiveness

May you be nearer, dearer, Father, I pray
with each breath I take, each beat my heart makes

Hallelujah! All honor, power and glory are yours
forever and ever

Amen

Fruitful Meditation

Love—
divine sparks igniting fire

Joy—
unconstrained eruption

Peace—
perfect, pure, Personal

Patience—
waiting, resting in You

Kindness—
overflowing, ever fresh

Goodness—
full of grace, mercy

Faithfulness—
heart of a holy child

Gentleness—
tenderly touching

Self-control—
obedient to Your will

To Love You

With all my heart—freely and fully
in perfect accordance with Your will,
for You are my very lifeblood and
the Power pulsing inside me

With all my soul—my true being,
eternal essence created in Your image
before conception, before birth
in a universe bound by time

With all my mind—Let us reason
together in peace and unity
May Your wisdom be instilled,
the fruition of holiness

With all my strength—for your Grace
is sufficient and Your power is
perfected in my weakness
I will celebrate my weakness

Becoming alive in Your Spirit
the Spirit of Truth,
the Spirit of Jesus Christ,
the Spirit of the Living God

Nearer to Paradise

Day by day I am,
and it bolsters me,
my hope, my strength
It gives me peace
and fills me with joy

It also presses me,
urges me to engage
with souls in this world,
speak of love divine,
live my life bravely

To believe perfect love
casts out fear,
to know love covers
a multitude of sins,
to help show others the way

My body is a temple,
home to the Holy Spirit
and a living sacrifice
I offer daily to God
in grateful service

Crucified with Christ,
I no longer live, it is
Christ who lives within me

He calls me
Be perfect, be holy

One with Him
as He is one
with the Father,
now an heir with Him
and all saints, forever

What a horror and
seeming curse to
witness humankind
sink lower than
Sodom and Gomorrah

Evil incarnate,
no need of proof
It surrounds us,
swallows us,
destroys us

The human heart,
who can understand?
It is too sick
to be healed by
any earthly power

What comes out
from within our hearts?
Jesus told us

It should appall us,
terrible but true

Read gospel of John
I dare you
Or are you one
living in the darkness,
preferring it to the light?

Jesus said clearly,
"You are either
for me or against me."
Time to choose,
why not life?

"I am the resurrection
and the life.
The one who believes
in me will live even
though they die."

For many who read
this, the words are
familiar, ring true
and become
the best news ever

Believe it, and you are
nearer to paradise

The Word Became Flesh

John 1:1-18 NIV

1 In the beginning was the Word, and the Word was with God, and the Word was God.

2 He was with God in the beginning.

3 Through him all things were made; without him nothing was made that has been made.

4 In him was life, and that life was the light of all mankind.

5 The light shines in the darkness, and the darkness has not overcome it.

6 There was a man sent from God whose name was John.

7 He came as a witness to testify concerning that light, so that through him all might believe.

8 He himself was not the light; he came only as a witness to the light.

9 The true light that gives light to everyone was coming into the world.

10 He was in the world, and though the world was made through him, the world did not recognize him.

11 He came to that which was his own, but his own did not receive him.

12 Yet to all who did receive him, to those who believed in his name, he gave the right to become children of God—

13 children born not of natural descent, nor of human decision or a husband's will, but born of God.

14 The Word became flesh and made his dwelling among us. We have seen his glory, the glory of the one and only Son, who came from the Father, full of grace and truth.

15 (John testified concerning him. He cried out, saying, "This is the one I spoke about when I said, 'He who comes after me has surpassed me because he was before me.'")

16 Out of his fullness we have all received grace in place of grace already given.

17 For the law was given through Moses; grace and truth came through Jesus Christ.

18 No one has ever seen God, but the one and only Son, who is himself God and is in closest relationship with the Father, has made him known.

Part 2
Falling

Topsy Turvy

Surely as an avalanche
sliding down a mountainside,
our world tumbles,
turning upside down,
light becoming night

Suddenly frozen in time, space,
breathless, lungs burning, eyes stinging,
hands clawing, useless
My life
so wrong for so long,
lusting, not loving
My flesh so weak yet strong,
crushing, not caring

My marriage, the avalanche
churning, dividing my family,
my wife, my girls, my boy,
following, falling
At the bottom,
the unholy trinity of
me, myself and I, thrown down
At the bottom,
the unhappy sight

of one, alone

One More

Hoping,
never expecting

So pure
and sweet,
a blissful taste
of what
may never be again

An expression
of the moment,
touching now

All joy
and peace,
a sudden gift
of love
with no promise

How pure,
how sweet

if only

For Real

I dreamed last night

We were in a little store
by the fruit stand,
sniffing, squeezing, sampling,
feeding each other,
juice running down our chins
laughing, trying more,
so fragrant and sweet

As we moved around,
our bodies kept touching
We wanted them to
There was warmth, closeness
We were connected
We were one
in body, mind and spirit

In the dream, we had
true intimacy
At least, that's my
interpretation

I want that for us

The Morning Fog

How appropriate,
and the greening grass
covered here and there
by patches of snow,
and the bare trees
budding now despite
forecast of snow
tomorrow

How appropriate,
surrounded by sounds
of familiar birds,
their singing jubilant
Yet I do not hear
the redbird calling
and I miss it today,
especially today

How appropriate,
this sympathy of nature,
this mixing of the seasons,
this uncertain light
Yet I know
the sun will rise,
the fog burn away,
the day warm, brighten

Later to cool again,
become sleepy and
fade into night
Then another day

Still I won't know
if I will meet your eyes,
excite your laughter,
thrill to your touch,
inhale your fragrance,
taste your beauty,
or capture your love
ever again

Sad, Sweet and Lovely

Such is the song,
such are the words
and the music,
but I cannot sing it,
nor can I play it
or say it

Though I have listened
many times,
memorized the words
and the tune,
wept so many tears,
sad, sweet tears

Tears of love
great joy and loss,
wiped them away
I have lived this song,
dreamed its dreams
with others

Cherished them for a while,
held them dear
shared, compared
stashed or dashed
quite a few
trashed even more

Promised promises,
dangling them,
mangling and
strangling them, like
a python squeezing
life from its prey

Vows we solemnly made,
each other betrayed,
our lives shattered,
scattered
like dead leaves
before the wind

I have no will to sing
or play the music
as I lay down
these soundless words
with my inkless pen
on this paperless page

Virtual is not virtuous
and I and my song
are at an end

I fear

Pride

I have known

scorn and ridicule,
unrighteous anger,
shunning,
conditional friendship,
loss of objectivity,
judgment

Know what?

My God knows my heart, my thoughts, my grief
My God hears my prayers, listens to me, speaks to me

My God lifts me up, gives me hope and peace
My God lived for me, died for me, rose again

My God loves me, cares for me, forgives me
My God defeated Satan, and sin, and death

My God opened the way to heaven, to life eternal
My God will give me my heart's desire

Simply to love and be loved
and I do, and I am

Amen

Times of Trial

Sometimes I get heartsick,
helpless to help loved ones

Especially you

I can't change the chain of events
leading to this moment,
undo what was done,
say what wasn't said,
be what I wasn't

I can't stop you or me or anyone
from playing the martyr,
from becoming some
tragic figure
on the stage of life

I am not God, nor want to be

Sometimes I get weary,
labor mightily like the Dutch boy
trying to fill the hole in the dike,
hold back rising water
I can't stem this force
of will, this prideful tide
swirling around me, threatening
to drown me and you

I can only let the past go,
like water flow out to sea,
rising now, forming clouds
raining down, clean and fresh

May it bring hope to you and me
those we love, those we hurt
those we lost

I can only take my place
among my brothers and sisters,
one in Body, Spirit and Life

We wait patiently, rejoicing in trials,
surrendering gladly, offering praise
to the only One who makes us more
by making us less

that One is Jesus

Forgiveness

Our Father in heaven
hates divorce,
but He loves us
Isn't that wonderful?

He knows even in great pain and sorrow and loss,
there can be still greater power and joy and gain

Witness

His Son dying on the cross,
the disciple's despair,
and sudden separation

The Lord's resurrection from the dead,
return to the living
and ascension on high

You see

He loves us still, forgives us, cares for us
He always will

Isn't that enough? More than we deserve?
All we'll ever need?

It is

Trust Him
His love never fails

My Helper

You are my comforter,
the gentle south breeze
rustling the leaves,
cooling my brow,
calming my spirit

You are my guide,
the rising half moon
illuminating my path,
improving my sight
this balmy June night

You are my guardian,
my faithful companion
standing beside me,
sniffing the air,
barking at our neighbor

You are my teacher,
the invisible crickets
chirping cheerfully,
inviting mystery
at end of a long day

You are my strength,
the endless power
filling empty heart,

restoring tired mind,
saving troubled soul

You are my truth,
my dearest friends
showing their love by
caring about me
and forgiving me

I thank you all
The dawn will come again,
morning blessings too,
and tender mercies,
ever bright and new

Part 3
Rising

Journey

One day, I lost my home and my way,
all hope slipping away,
and the rain started falling

Darkness crept over me as I leaned
against the cold, wet wind
and the rain kept falling

I passed by your door
You saw me and called to me,
while the rain was falling

You invited me inside and showed me
kindness, shared comforts,
Outside the rain was falling

Your fire gave warmth, your eyes
shone, my soul fed upon them
I listened to the rain falling

You whispered secrets, spoke
of dreams, touched my heart,
and the rain stopped falling

The sky began to clear
The sun appeared
and I could see beauty

for the first time
in a long, long while

To My Muse

Daffodils for you,
a sure sign of spring,
almost as much
as the joy
in red robin's singing,
or the lilies that signify
our Lord's rising

From me to you and now,
like that flower on a sad day
Jesus is my sunshine,
like that bird chirping away
Jesus is my song,
like the hope growing inside me
Jesus is my light

My Savior, my Lord, my Joy,
my Love, my Life

Life

Full of surprises,
sometimes pleasant ones

A fox panting in a field
of plump cottontails

An otter scampering and sliding
down a riverbank

A nighthawk soaring, slashing
through a mosquito cloud

Fireflies flashing on a misty,
gray summer night

The moon shining on me
like the face of God

Jesus's eyes gazing into mine
with the light of Love

Glory

Oh, beautiful night
Oh, shining moon
Oh, face of Jesus
Oh, peace of Light

I love You

Two Paintings

Two lives, both mine,
sort of like those
before and after photos
you see on TV
Each represents a period in my life
Each is equally true of me,
the purchaser of the paintings

I stand before them, admire them
hanging on the walls in my
lake house, where I live now
Each is of an outdoor scene,
the first in acrylic, hard and stark
the second in pastels,
soft and appealing

The first of two men in a small boat
fishing at dawn on the Missouri River,
not far from shore
A fringe of green grass
lines the foreground,
a subtle sign of spring ascending,
new growth to come

Slender, bare trees cast shadows
on sand and rock
The artist playing with shades

of yellow, tan, pink
Water ripples near shore
as the two men cast eyes
and lures toward fish unseen

Forms of men and boat
are mirrored in the water,
brightened by a shaft of yellow light
slanting through lifting fog
Look closely and see
one pole bends in a graceful arc,
a fish on the other end

Gaze now upon the second canvas
a summer garden lush with flowers,
fragrance and color
It may be morning, no later
than midday
Green lawn divides
and outlines flower beds
for full appreciation

On either side, trees rise to the rear
broadleaf on the left, conifer on the right
framing a patch of sky
Through it one can see
in the near distance a pond, or slough,
giving way to tall grass,
more trees on the horizon

Above is a blue sky, puffy white clouds
promising fair weather,
a peaceful present, a bountiful future
In the foreground, unseen,
you and I are casually strolling,
arm in arm, talking and laughing,
or just looking, taking it all in

A Rich Mullins Morning

Sometimes the night
is beautiful
Sometimes the day
brings glory

Sometimes God
is larger than life,
almost near enough
to touch and hold

May we endure
longer than the flowers,
the swelling sea,
or circling moon

May we be true
children of God,
members of His body,
part of His family

Praising Him,
adoring Him,
giving thanks to Him,
glorifying Him

Bowing before Him,
resting in Him,
worshiping Him,
living for Him

Plum Wild

Sunday, a day of rest, and
sometimes adventure, discovery

Loading our mountain bikes,
driving to a state recreation area
along the river at edge of city
yet somehow hidden, little-used

Leaving dogs, family, work and
cares behind us
It's mid-August,
a cloudless sky, burning sun,
Fortunately, a breeze to cool

Following signs A parking area,
then a few campsites
a playground, picnic tables
All are empty We're alone

An asphalt bike path
We sprint through sumac and
scrub oak, meadows thick
with Canadian thistle

Dragonflies hover above us
ever alert for predators, and prey
We hear the screech of a blue jay,

raucous and piercing,
as it flies away
unseen beyond a line of trees

Following a dirt trail now,
overgrown and shadowy,
leading to a riverbank
We come to a wooden footbridge
crossing over shallow water
We're on the other side now

At the top of a signpost, we see
a board with white-painted figure
of a cross-country skier
We'd be skiing if the season
and conditions were right
and we had the time to do it

We see a sign with an arrow
pointing up the draw toward
archery range with straw bales,
targets strategically placed
for would-be hunters,
although none are present

We pause to take in the scene,
the sweet scent of clover,
colorful splash of coneflowers,
the escape of a blue heron
We ride fast through tall grass,

flies and bees buzzing around us

The trail steepens; we walk our bikes,
wishing we'd brought along
bottles of water instead of root beer
we left in the car, getting hot
Stopping to rest near a thicket,
we survey our surroundings

Praise and thanks be to God!
Wild plum trees
loaded with ripe fruit
Picking, sharing it
Skin tough, but beneath
tender pulp, dripping nectar

Starting again, we climb
steadily, reaching the ridge,
flushing a young whitetail
along the way

Standing now, we study the view
across the valley and see houses
at a comfortable distance,
evidence of civilization

Descending at last, we pass
under steel towers supporting
high-voltage powerlines
It's time for some serious fun!

A race back to the car,
laughing, loving every minute

Promises to return one day,
to once more drink deeply
of God's magnificent creation,
to partake of life abundant,
discovering together
what Sabbath really means

In the Cloudy Morning

of today, the 48th anniversary
of my biological birthday
Another day in a string of days
unusually hot even for August

The sky is overcast; it tantalizes rain
with distant lightning, rumble of thunder
Only a few drops fall, the rain mostly
missing, moving farther south and east

The grass looks parched on the hill
Down below, the river is almost dry
The city pumps millions of gallons
from its wells, draining aquifer

Stricter restrictions begin today
and talk of more in weeks to come
Life on the prairie is precarious at best,
Yet living here is worthwhile

I hear a redbird singing atop tall pine tree
A rabbit flushes underfoot
Molly and Sweetie, our two boxers,
dance in a circle in mock battle

They don't see the deer in the distance
escaping along the fence

after feeding on fallen apples
Their attention is on each other

I'm happy, really, at peace, even
Trusting, believing all will be well,
no matter what happens today,
no matter what trials come my way

I'm prepared for violent storms,
change of seasons, harsh climate
I know all things work for the good
of those who love God

I have seen fertile soil yield
bountiful harvests with just enough rain
I have witnessed God work miracles
in the lives of many, especially mine

I love you, Lord
You are ever, always
with me and will be
'til the end of the age

An Apology

You know me, you've seen me
at my best and my worst
Storm clouds gather, my mood darkens
becomes foul, lowdown, mean

Inevitably, I start backsliding,
blindsiding
The words strike quick
the way angry hornets sting

You chastise me, it reminds me of
who I am and why our Lord had to die

I already knew we have only
two wells from which to draw
Drink from one, receive living water
Drink from the other, risk lake of fire

So call me a hypocrite, self-righteous,
egotistical, a pious fool
They all fit me when I pit lies against Truth
flesh against Spirit, me against you

So tell me, please, I need to hear it again
How does it go? Remind me of the Word

Our Lord said, Do unto others

as you would have them do unto you
Love your neighbor as yourself
Judge not lest you be judged

Turn the other cheek
Humble yourself
Pick up your cross
and follow Me

Love the Lord your God
with all your heart
with all your soul
with all your mind
with all your strength

And remember,
we could never be worthy
He makes us worthy
by His shed blood,
by the victory won
on Calvary's cross

Amen

Fret Not

Why, you ask? Hey!
What does the Good Book say?
It leads only to evil doing
So, what to do?

Seek first His kingdom
and His righteousness
and all these things
shall be added unto you

What not to do?

Don't be anxious for tomorrow
It will take care of itself
Each day has trouble
enough of its own

Trust in the Lord and do good
Dwell in the land and cultivate
faithfulness and He will give you
the desires of your heart

Commit your way to the Lord
Trust in Him; He will bring forth
your righteousness as the light,
your judgment as the noonday

Then what?

Rest in the Lord and wait
patiently for Him
He will give you peace
that surpasses understanding

"Peace I leave with you
My peace I give to you
Not as the world gives
do I give to you
Let not your heart
be troubled, nor
let it be fearful."

Wow! What a promise

Sounds great, huh?
If only you cease striving
and know He is God, you have
nothing to worry about

Praise God! Thanks be to God!

Amen

The Great Commission
Matthew 28:16-20 NIV

16 Then the eleven disciples went to Galilee, to the mountain where Jesus had told them to go.

17 When they saw him, they worshiped him; but some doubted.

18 Then Jesus came to them and said, "All authority in heaven and on earth has been given to me.

19 Therefore go and make disciples of all nations, baptizing them in the name of the Father and of the Son and of the Holy Spirit,

20 and teaching them to obey everything I have commanded you. And surely I am with you always, to the very end of the age."

Part 4
Reminiscing

Camp Lincoln

Boys Camp, Lake Hubert, north of Brainerd, MN
It offered Family Camp, too, when I was there
Girls Camp was located on the other side of lake

Four weeks, two summers, ages 9 and 10, but very
close to my next birthday Family would come visit
on a specified weekend midway through session

My younger brother Jeff was there at the same
time my second year, also his only year
He became very ill, needed to be hospitalized

Highlight for me was playing Jeff's team
in a softball game before he got sick
He was always a much better athlete

Both of us were highly competitive I pitched
to Jeff with bases loaded, top of the 9th inning,
two outs, my team leading by a single run

The previous batter had hit a hard line drive
directly at me, so I put out my right hand
to stop the ball It kept a run from scoring

Broke the middle finger on my pitching hand
Man! that really hurt The game stopped for awhile
I wasn't coming out Jeff was up to bat

He stood at the plate like Casey,
the mighty Mudville slugger
We were all business, adrenaline pumping

For those familiar with the poem, you know
how the story ends Bases loaded, thrice
Casey swings, and yes, bother Jeff struck out

It earned me a trip to town, icing my finger
First an X-ray, then taping a splint on my finger
It limited my activities but I still had a great time

Youngest brother Brad's two years at camp
didn't overlap with mine His experience was
as memorable as mine, and as Jeff's, I suppose

The great thing was the friends we made,
the sports we learned, like archery and sailing,
the songs we sang, never to forget

The most life-changing experience I had
was being taught the JOY principle,
Jesus, Others, Yourself, in that order

It was a seed planted, simple as can be
Only for far too many years, I had
the order reversed Sadly, it still happens

But the Holy Spirit is quick to correct me,

in an instant, even What a difference
It's a miracle, Lord, your order is perfect

Amen

Fortune and Fame

Catherine

My high school sweetheart, Platonic love only
She made my heart flutter, too afraid to tell her
A good friend, she listened to my dreams,
overlooked my faults and foolishness

Both of us were from large families
Hers was Catholic; mine was agnostic
Things came easily to her; she took up tennis
and won two state championships

Things came hard to me; took up vice
and lost nearly everything We went to
different high schools, took different paths,
occasionally crossing, reaffirming friendship

For her, law school and marrying a classmate,
then moving to Boston to begin their practices
Played lottery once; chose siblings' ages,
something like that She won more than a million

For me, party school, skiing more than studying
Spent all my money and moved back home
Played at life and pretended to work, then I
returned to school, got married, had kids

Help me, Lord

Barb

We were closest in junior high school,
two smart kids, two kindred souls
She was advanced in every way
including physically She made my body stir

Both of us came from large families
Hers was successful; mine seemingly so
Things came less easily to her,
great creativity hidden inside her

Things came hard to me, great longings
locked inside me We went to the same high school,
following different paths, mostly diverging
You might say we had an ethereal friendship

For her, art school, staying single, at first
following her star She made many films,
but they weren't the Hollywood type
One about her mom, bikers, won an Oscar

For me, I took many classes and
had many careers start and fizzle
Finally got serious, listened to my father,
heard my Father and became a physician

Thank you, Lord

My treasure is in heaven
My name is in Your book
My life is in Your hands

Amen

For My Soul

An idea comes to mind and nestles there
a few words, a phrase or two, possibly a title

Then I sit and wait like a mother hen
atop her egg, thoughts drifting
eyes resting, time passing

Awake now, excited, expectant
About to give birth to a new creation,
revealing itself

One peck, one crack
one chip, one feature
at a time

Another image

A sculptor holds his hammer and chisel
and looks at the marble block
resting in front of him

Now he circles around it,
studying, reading, realizing
the shape inside the stone

Removing the excess,
leaving the essential,
a labor of love

Still another image

Sunday at the First Baptist Church
in Vermillion, South Dakota It's January
and Pastor Eric Holmstrom is officiating

The sacrament of baptism, mine
Tank heater is broken,
Pastor in waders, shivering,
mentions the old days, breaking river ice

Dressed in a thin robe over other clothing,
I'm not feeling the cold much at all,
strangely warm and at peace

My family watches the immersion and
emergence of new life, reborn in Spirit,
a new member, a new family, child of God

To be revealed and perfected
one crack, one chip,
one feature at a time

To be made holy, pure, perfect
Removing the excess,
leaving the essential

a labor of love

His love

Crow Chasing Owl

Another splendid day just past mid of May,
overnight rain shower adding sheen to green
I slept well enough, but awaken recalling
dreams, old themes of exposed inadequacies

With a shudder, I make use of the bathroom,
then fill pill bars for the week ahead

On Saturday, I plan to fly to Atlanta
to the APA's annual meeting of psychiatrists
It should be exciting, my first time going,
returning to a city I visited as a youth

I have much on my mind A patient I met with
on Friday, again on Monday, has disappeared
Lots happening in my personal life, too
Nothing new, really, just more of the same

Now I'm deep in thought, deeper in prayer,
my past to present, my self laid bare
Trust in the Lord, delight in Him
Be still and know He is God

Late for work now, only a little
Rushing, a little, feeling at peace
I'm in my Ford Explorer heading up driveway

and I see them flying from the trees below

Crow chasing owl

And it hits me, God's message
for me, for today It's funny, wise

We owl have our problems

Medicine Man

Pain, sometimes an objective finding

Visible on face, grimacing, wincing
Full of sound and fury, screaming, cursing
Palpable with applied pressure,
guarding, rebound tenderness

Usually, pain is subjective and by report only
It may be characterized in several ways
Its location, onset and duration
It localizes or radiates

It's described by its quality, dull, or sharp
constant, or intermittent
Or by its quantity, scale of 1 to 10
interference with function

The pain business It's what I do
Physical pain, emotional, mental, spiritual
Can't separate it Pain is holistic
Yet must diagnose, categorize, so can treat

My patient's pain, and mine

It might be medication, a gift from God
to feel, function better, so can face problems
Might be word therapy, psychological techniques

Insight-oriented, supportive only

It might be referral to proper specialist
neurologist, orthopedist, "real" doctors
Might be wise counsel from priest, pastor, rabbi,
another type of Word therapy from infallible source

I am

in pain business, but also hope business
Must always offer it, maintain optimism

Even when I'm in pain, can't let it show,
let others know, or maybe just a little
It humanizes me, helps patients
see, hear, feel their own pain

It gives me authority, makes me an expert
by personal experience, not just training, treating
It has great healing power, listening, sharing,
exploring, believing their pain, and mine

The Bible says we should
rejoice in our trials
God promises

A place for the meek
Comfort for those who mourn
Righteousness for those
who thirst and hunger

Mercy for the merciful
Heaven for the poor in spirit
His face for the pure in heart
His family for those
who make peace and
are persecuted for Him

for He is Hope, Light, Life
Truth, Peace, Joy

He is Love

And good medicine for the medicine man
who hurts, too, needs help, too
First, to love and serve his Lord
Then, to love and serve His children

Amen

Praising You, Lord

for the day, for the rain on the dry grass,
for breaking my heart the way it needed
to be broken and coming to live inside it,
for making it new, for making me new
a new creature, a new creation

How You bless me, allow me to live
fresh and free, giving me this little
house on the shore of a prairie lake

I stand now by the big picture window
admiring Your work, then become lost
in thoughts of today, what needs to be
Out of the corner of my eye, I see
wide-spread wings for a moment

I turn to look behind the pile of branches
on the rocky shore just in time to see a lone
white pelican swim from beneath willow tree
into my view and tilt its head back,
swallowing its catch

That fish, that prey, is me, and like Jonah
in the belly of a fish, I know I am caught,
know I have a mission I must do, complete

But You have already tested me, spit me out

upon the dry land Anger and hatred,
sorrow and suffering are familiar to me
But I tasted and saw that the Lord is good
Your mercy endures

Now I live in a garden, this wild, lush place
where You placed me, with all my needs
provided, even all the modern conveniences

You even water this lovely, natural garden
while You water me, so I can water
Your children who are ill mentally,
emotionally, often in pain physically
and spiritually, and I can identify with that

For You offer them the Living water
streaming from You through me
to them, and You give it to all who believe

Amen

Jackson Park

Look! Three pelicans
flying as one
white against blue sky
reflecting sun

A trinity of nature on display

I remark as we walk
in the park, myself,
granddaughter and son

Hey! I could write a poem
You know what? I have!
It's already done

Redbird and Robin

I listen through my open window
Somewhere in the gray dawn
alternating, I hear each singing
singular, thrilling song

Wishing so much
I could join them
waiting, praying
for my muse to come along

To sing praise to the Lord
Sing praise to the One
Lord God Almighty
Father Spirit Son

Seasons, years come and go,
my sojourn north is now past
Spring again, I see them,
joyful in morning light

Two robins dancing
on the backyard fence,
one fat and fertile,
soon to sit on her nest

Redbird at top of a tree
thrilling me again

This is his tree
its space he will defend

So much has changed for me
So much has stayed the same
From end to new beginning,
I know my Lover's name

I am His beloved
He, the Lover of my soul
Softly wooing He sings
the sweetest song of all

Bridegroom and Bride,
it's our Wedding Day at last
Many are admitted here
but only if they ask

Dream Fishing

Fondest childhood memory, perhaps
Drowsy summer days fishing,
often dawn until dusk, sometimes
long after dark

Catching, nearly always releasing,
fish of every stripe and color
Panfish, bluegill, crappie, perch
Gamefish, walleye, northern, bass
Rough fish, sheepshead, carp, gar

Now and then keeping, cleaning, cooking
Fish fry! Neighborhood kids eating,
avoiding sharp bones, laughing
about catch of the day Surprise!
Turtle, blackbird, scalp

I have recurrent night dreams of fishing
Standing on a lakeshore, watching
Wading in a cold stream, casting
Sitting in a small boat, trolling
It can be daytime or nighttime

Hooking something, line pulling,
pole bending, heart pounding
Then disaster! Line breaking
Pole snapping Feet slipping

Boat capsizing, me swimming

Even worse!
Discovering the fish
is really some monster,
an angry alligator
or a hungry shark

The past two nights, the dreams
had a different outcome,
lightest of lines never breaking,
flimsiest of poles never snapping,
feet firmly planted, boat barely tipping

I was neither gaining, nor losing,
merely battling my unseen foe
Then I realize in this life,
it's the best I can do For to gain my prize,
I must first cross over the water

Bill

Great friend to my mother and father
Went through a lot together

Mary and Bob, Bill and Margaret

College, the war, marriage, kids
Sharing life's dreams,
Struggling to make it
in the work-a-day world

Bill and Margaret had four daughters
each a lovely bloom
and a blessing to both
mother and father, but no son

Then I came along to Bob and Mary,
son number two, a namesake!
For Bill, of course, and my father
A double blessing for me

I remember us visiting Bill and Margaret,
jokes about leaving me with them
Everyone laughing except me
I was crying, of course

Then Bill would take me, show me
a few of his marvelous antiques

and give me one, a Tom Thumb knife,
or an agate shooter, and I'd smile again

I especially remember their music,
Bill fingering the harpsichord
or playing the piano, my dad singing,
the two sharing songs of their generation

And seeing Bill's face, his eyebrows raised,
his glance turned toward me with
a twinkle in his eye, the smile of a fox
beneath that pencil-thin mustache

Most of all, I remember
Bill's wit, as sharp as any
scalpel he used to cut disease
from his patients' bodies

No one could cut the cancer
from his body until the Great Surgeon
took him home, his family gathered,
urging him, "Go, Bill, go!"

My mom and dad decided
It's too far, they're too old
to walk and stand, to kneel and pray
To pay tribute to Bill and his family

A tough decision, me offering
to go instead and represent our family

A good idea, not a practical one
It was a tough decision for me, too

So I offer up this poem instead
It's a eulogy for you, Bill
I loved you as a father
You were my friend, too

I'll miss you, too

Alma and Abigail

The Graff boys, Gordy, Tom and Jon
The Giebink boys, Bobby, Jeff and Brad
It was summertime at Lake Okoboji
We were growin' up, havin' fun

Good, clean fun, innocent fun,
more or less, carefree, anyway
We lived close together at the Lake,
and for a time in Sioux Falls

I might spend the night in the Graffs'
guest house with Gordy, perched
on the rocky shore and connected to the dock
It had a strong, old cabin smell

The walls were so thin you could
listen to lake sounds or night roamers
We'd wake up early to be the first to fish,
maybe go in the boat after the big ones

We'd have breakfast, whatever Alma fixed,
always good food, even better company
Called her Gramma, only Gramma we
Giebink boys ever had, she was the best

Then there was Abigail, Gramma's dog,
basset hound, she howled a lot

Friendliest dog, Grammas' companion
She drooled, and waddled when she walked

We'd go to Gerk's Resort to jump on the
trampolines, until Gerk appeared, ran us off
Sometimes, we'd buy candy He'd take
our money, grumble a little, let us jump again

On the 4th of July, we had a great time
Exploding firecrackers, cans, mailboxes
Still too young to pay much attention to girls
Interesting creatures, perfect targets for pranks

Evenings were fine, the day beginning to cool
We'd stay outside until mosquitos drove us in
Then it was time for playing cards,
drinking Kool-Aid and shooting the breeze

Last time I visited Gramma she was 90, living
by herself in a trailer in Colman, her mind
as sharp as ever, wonderful, warm smile
Love was flowing from her
I didn't want to stop huggin' her

A couple of years later, I heard she died
I was invited to her funeral Wouldn't have
missed it for the world She was a person who
had played a major part in my life and world

The Graff boys were there, Gordy, Tom and Jon

The Giebink boys were there, Bob, Jeff and Brad
Assorted spouses, children, a family time, for sure
Pastor knew Alma well I learned about her life

We sang hymns
We laughed and cried
We felt amazing grace
We got a glimpse of heaven

I'll see you soon, Gramma

Aunt Carole

You were Queen Carole to me
Your younger sister, my mom,
played the fair Princess Mary
You were the athletic one
You lived your dream for a time,
a year as a professional ice skater

You ruled a small world You had
a modest house and a well-kept yard
at 4937 Lyndale Avenue South
near where you and Mary grew up
in old Minneapolis,
not far from Lake Harriet

You grew up under the watchful eye,
stern hand of Lord Conrad, your father,
treasurer of the University,
and under the happy gaze, tender touch
and warm embrace of your beloved
and esteemed mother, Adele

You married Sir Charles, only
everyone called him Chuck
He was as blue collar as can be
Your two children, Sandy and John,
blessed you with grandchildren
and filled your heart with treasure

Gave you headaches and heartaches, too

Such is life, and, inevitably, death
Sometimes death comes too soon
as it did with son John, tragically flawed
He was gifted, popular, full of life and humor,
but a slave to the lures and demons of alcohol

I know something of that myself, personally
and professionally, by what God called me to do
I know something of you and your world,
Aunt Carole, and what you gave to me
I visited you often, first as a child,
then later as an adult with my children

I stayed upstairs sleeping in a bed so soft,
after climbing stairs that seemed so steep
Jets would roar overhead and the street
was ever noisy with traffic It scared me
at first, but then I got to like it,
liked staying there with you, Aunt Carole

I loved talking to you, but mostly listened
You always had so much to say
I remember your pet, Bugs, the bunny
Funny, named the second one Bugs, too
Hopped around the house, nibbled on things,
including fingers; had sharp teeth

I remember going downstairs where
you kept the malt machine
I had to have chocolate, yum
That's where Chuck's work area was, too
He kept his tools and materials there
He could fix just about anything

You loved your birds and your squirrels
and fed them, just like your sister, Mary
You two were homebodies by nature,
but circumstances led Mary and her
physician husband, Bob, to move and
the family traveled for vacations

You and Chuck would come and stay
in our guest cabin at Lake Okoboji
What fun it was to have you visit
us there, but then Chuck died It got
to be too hard to have someone
take you there and bring you home

So, I'd come to visit you, Carole, and I'd write,
send letters and cards to you, enclosing photos
of my kids When I visited, you had photos
to show me and letters for me to read
You were eager to share the contents

I didn't mind that you had shown me
the photos, that I had read the letters
on previous visits I didn't think much

about it at the time You were well
into your 80s by then and
I understood about aging

I was glad the drinking had stopped
not long after Chuck passed away
I thought alcohol might be a factor,
but the memory problems were more
than that Your daughter Sandy told us
you had Alzheimer's dementia

Your memory and mind and body were
deteriorating rapidly Sad news,
to say the least, and a burden for Sandy,
but it was one she took up gladly
In many ways, Sandy is like you, Carole,
she has a heart of gold, too

You could no longer live in your house
or rule over your tidy, little world
In time, your own brain and body
would betray you, despite a brave fight
The news came last night, an email
sent to my sister and forwarded to me

It came from Sandy and gave the details
in such a clear, loving way
About five weeks ago, you broke your hip
You had surgery, which went well enough
You didn't have much pain, but afterward,

Sandy said you were never the same

She said you gradually stopped eating,
even getting you to drink water was a challenge
Sandy said you had been frail in the past year
You used a walker, but after the surgery,
you stopped using it However, you were
able to celebrate your 90th birthday this year

I wish I'd been there, wish I'd visited
you one more time, Carole, somewhere
along the way Sandy said you could
do nothing for yourself at the end, but
your care had been wonderful
I'm sure Sandy appreciated it

I wish I'd cared more and remembered
more before today, before just now
Sandy said you started hospice program
the day before you died
You were tired and ready, ready to die
You did, early in the morning

You were a poor dear who had had enough
Many of the words I'm using now belong
to Sandy She wrote them and she felt them
She was the one who was close to you

But I hope to be able to visit with you again,
Aunt Carole, when I make my final journey,

when I pass from this world to the next
and from this life to an eternal one of bliss

We'll both be in the presence of our Lord
and King, Jesus, the Ruler of all that is in
heaven and on earth, and we will worship
and praise Him in a day that never ends

Amen

Height Of Life

Buying, modifying an adult trike for my
December 4th will be 89-year-old father
so he can ride one more time, but I call it
a "3- wheeler" 'cuz it sounds better

I pick it up Saturday, last day in April
The warm weather that spurred our interest
has given way to a late cold spell, rolling
clouds, brisk breeze, sudden snow showers

We adjust the seat as high as it can go
and he can still safely get on and off
It's the only way he can pedal after having
Knee and back surgeries, both hips replaced

He once practiced as an orthopedic surgeon
He was a pioneer in his field, one of the first
in South Dakota to do total hip replacement,
not long after that having the surgery himself

Now, he lives alone and he's a lonely man
Mary, his helpmate, mother of his children, keeper of
his home, friend, lover, soulmate, partner in life for
more than 60 years has been gone eight months now

Uncertain at first, now gaining confidence,
he finds a way to work the mechanism that locks

hand brake He squeezes and pushes the button,
but he has to stand and use both hands

I'm patient as we move the seat up
to find the proper height and he practices
getting on and off, starting and stopping,
going into and out of the garage

When I first arrived, he was having lunch,
a bowl of soup and some orange slices
I went downstairs and played pinball,
waited for him, no reason to rush him

He had visited friends earlier, had dressed
for the weather, wore several layers, but in
his excitement, he forgot to take a jacket
He might want one, but I didn't say anything

He can ride the trike only halfway up our long
driveway to the broad curve, where he turns
to go back down amid evergreens, songbirds
singing, no longer can he hear them

He said he was cold, but he stuck with it
He rode around the large space at the lower
end of the driveway until he was doing
figure eights with me admiring him

In the beginning, in the garage,
he was clumsy, maneuvering the trike

so it was facing out, but by the end
he was dancing in time with it

He was pleased with himself and the trike
We were both glad we had persevered and
not given up on the idea and followed
through with getting him one

We had decided to pay for the trike by
"going halvsies" with him paying
a little more as I did the "legwork"
and will get it when he's done using it

Much of the time while I'm helping him,
I think about teaching my own
children to ride, and now my daughter is
teaching hers I smile at the thought

I remember one autumn day my father,
and my namesake, driving me to high school
in the '68 Corvette with the top down
He pointed out a perfectly shaped maple tree

All of its leaves were a flaming red
He said the tree was the epitome of autumn
I learned a new word that day and formed
a memory that has stayed in my mind

Later, in a college psychology class,
I would learn about the different stages

of the human life cycle; I'm in the generative
stage of my life, the most productive stage

It's the time in my life when I have
the most responsibility, the most challenges,
the most rewards, the most burdens,
but I don't really look at it that way

To me, the burdens are blessings
I choose to rejoice in my trials, for
the joy of the Lord is my strength
Each day He gives to me, I rejoice

I rejoice and am glad, for each day brings
me closer to meeting Him, to sitting at His table,
to seeing His face, to joining other saints
and partaking of the wedding feast

I know I am following the way of my father
It is a path of gradual, then quickening decline,
We both witnessed his wife, my mother,
become increasingly frail, then fail and die

But I know the higher Way to my
Father in heaven, I'm following my
Lord Jesus Christ, my mother before me,
and, I pray, you'll go that Way, too

Amen

Part 5
Expecting

The Fallen Will Rise

In the garden of Eden, the tree of life
Eating freely from it
Naked but not knowing it
Walking and talking
in the perfect morning
with the Maker of everything

Fallen angel, once favored,
called bearer of light, now a serpent,
crawling on belly, tempting
Eat from this tree, be a god
Know what He knows
It's a most delicious fruit

Yes, knowing good and evil
Naked and afraid, ashamed
Cut off from Him, the tree of life
Covering and hiding, impossible
You shall surely die
for you have surely fallen

Expelled from the garden
Living in a world ruled
by the Prince of Darkness,
a place of sin and death,
endless war and hate,
a race to destruction

But You entered this world,
light into the darkness,
offering a new way, hope
The Prince of Peace,
You give life abundant,
Yourself in our place

Descended to the dead
until risen again, then
called home by the Father,
assuming your rightful place,
at God's mighty right hand
as King of angels, heaven, earth

The promise of a Helper,
Your Spirit, Truth, Power of God
Disciples will remember everything
You said and did Believers will do
greater things, sharing the Gospel,
building a heavenly Kingdom

Sin and death are defeated
and Victory won, but the Enemy,
a liar and father of all lies,
is not yet yoked, dethroned,
cast into the lake of fire
with his demonic followers

It is time now for us, living stones,

to add more stones to
the Cornerstone before the
Capstone is fitted at last
No more future, present,
past, only a day with no end

It's not easy for me to wait for
my mansion in this aging tent
Senior moments multiply
I see myself becoming
much like how my dad was,
life humbling me as I age

He was a servant of first order,
a leader in war and peace,
Member of the Greatest Generation,
he had his spring and summer
then came his fall and winter
He let go of life with grace

He was best in the storms of life,
became calmer as a crisis grew bigger
Unlike myself, who must keep
my eyes fixed on my Savior, Jesus,
or I will quickly sink deep
beneath the turbulent waters

I have surely fallen, eaten
fruit from the deadly tree,
lived big, spent it all

Broken down, turned around
Father came running to me
restored me as His own

I realize now it's not my time
anyway, it's His I am His
I count my every blessing,
rejoice and give Him praise
Power perfected in weakness
All sufficient is His grace

Recalling your promise,
sometimes I look skyward,
and wonder Will I still be here
to witness Your return from
heavenly home above,
Jesus, God of Love?

Rapture

Lean not
on your own understanding
but fall on your knees
before the crimson cross,
then lift your eyes heavenward
searching for the Son of God

He will come
with His host of angels,
raise you up on that glorious day,
invite you to His table and kingdom,
anoint and bless you and call you
His forevermore

Amen

A Royal Makeover

Internal growth, physical, developmental
Anticipation, expectation, parental
At last turbulent, traumatic passage
The promised pain of labor and birth

Holding proverbial bundle of joy
Baby is the very picture of innocence
Now crying, demanding, impatient
Assuring all bodily needs are met

So soon baby is smiling, giggling, grasping
Endearing and strengthening bond
Not long before beginning to verbalize
those sweet words, "ma-ma" "da-da"

Not much longer before hearing
the rebellious "no" and with it,
resistance, an ancient, innate behavior,
the child expressing unholy template

The age of personal accountability
or rather, the moment of it
When does that happen in a child?
What decides the beginning?

Sadly, we have much of the answer
Conceived in sin, born in sin

Such wonderful goodness in many,
yet we're tainted by an awful illness

It's an affliction shared by all
To deny it is to deny our very nature,
to try to make a liar of our Creator
and set ourselves up as gods

It harkens us back to the garden,
losing the tree of life for a lie,
Knowledge of good and evil is
first fruit of the father of lies

Worshipping, seeking external beauty
Reaping, finding eternal death,
the promise of lake of fire and
final separation from Lord of Life

The reality of evil is daily accepted,
the free gift of salvation often rejected
The life of the God man is denied,
His devoted followers despised

More than 100 thousand are martyred
every year for holding their beliefs,
for being people of the Way,
of the Truth and of the Life

They are joint heirs of the Kingdom
Members of a royal priesthood

Brothers and sisters in Christ Jesus
Children in the family of God

Washed in water and the blood
Indwelt by the Holy Spirit of God
Names written in the Lamb's Book of Life
Citizens of the Celestial City

Freed from the slavery of sin
Given garments gleaming white
Living in a day that has no night
Possessing new name, new home

Illumination comes from a divine source,
the very presence of Yahweh
They kneel before the royal throne
and know as they are known

A Ringing Silence

Calling, crying out painful, desperate pleas
that fall on ears that refuse to hear,
that fail to move willful, hardened hearts
and greedy, closed minds

The gap ever widens between the haves,
anything that can possibly be had,
and the have-nots, never enough
of even the essentials

Cutting, drilling, digging, processing,
growing, harvesting, catching, gutting
resources from land and sea, creating
depleted, toxic earth

The privileged few amassing power,
wasteful wealth, living for the sake of luxury,
oblivious to the needful, profiting from the toil
of underpaid workers

No person can serve two masters Hate
the one, love the other Hold to the one,
despise the other You cannot serve
God and money

Store up your treasure in heaven where
moth, rust do not destroy or thieves

break in or steal, for where your treasure
is, there your heart will be

Choose this day whom you will serve
As for me and my family, we will serve the Lord

Help

Feeling weight of the world
Standing on edge of a precipice
Falling into a deep, dark pit
No bottom, no relief

Crying out into the silence
Where are you?
Getting lost in the wilderness
Where am I?

Feeding on your Word
It burns like fire
It reveals truth about You
and me

I had wandered off course,
lost sight of you, started
sinking long before
stepping out of the boat

Jesus, please, lift me up

Light my way
Be my peace
Lead me on
Walk me home

Amen

Otherness

There is self and selfless, otherness and togetherness
It's all about attitude, orientation, focus, purpose
Who comes first?

There is aloneness and isolation,
competition and separation
Get ahead at all costs
All about me, mine
Many getting left behind

Today, this morning, late July, all wrapped up in me
Walking to the UPS store,
somewhere between anxious, hopeful
My goal is to fax 23 pages of my life

Thankful for the day,
rejoicing in the day, a glorious day
Finally finding a measure of peace in a year
of great testing and turmoil

Heading west, crossing the street Ahead of me I see
a twosome moving on the sidewalk toward me
My mind fixes on them
My heart is taken by them

Two women, one has white hair,
using a walker, wheels in front

She wears a faded summer dress
fitting of her age and era,
moving slowly, steadily forward

On her left is a younger woman, taller,
dark hair, red shirt, in step and attentive
Her right hand is on the walker, too,
helping to support, balance

What a blessing for me to witness!
The two together, I the other
appreciating the beauty of their relationship,
of giving, sharing, receiving

Not wanting to disturb them on their walk
or the moment, I turn south,
cross the street and continue on my way,
feeling the oneness

My experience at the UPS store is a little hectic,
only one of two computers
are operational to assist customers
I'm in no hurry

While I'm standing there my muse appears,
rather the Holy Spirit inspires me,
and I begin writing this poem on
the outside of a UPS bag

Walking home, it's sunny and hot

Staying in the shade of trees,
I'm deep into myself, a reverie
I stop, look left, then up
I see the height of majesty
It's a massive maple tree

Planted about the time
I was born, its trunk as wide as I am tall,
perfectly proportioned, healthy

And it comes to me Be still, know I am
Yes, Lord, I know, and I am still,
and we are together

Oneness

I'm beginning to understand
that living in You is knowing
You living in me,
being alive in You

At the table with You,
Your Word my daily bread,
Your Spirit my living water,
Your Love my holy blessing

How can this be?
It is too wonderful,
too amazing for me
Yet my faith affirms

Your promise of oneness
with You, with the Father
It requires nothing more,
demands nothing less

Than You as the Way of life,
You as the Truth of life,
You as the very Life and
no one and nothing besides

Amen

Eternal Embrace

I had a thought today,
one thing I want to know
Is there huggin' in heaven?
I truly hope it's so

But if it's not to be,
I think I may know why
No need for such touchin'
in the sweet by and by

Where We Are

You are ever, always I am

Why did it take this long for me to be still enough
to hear You whispering in my ear,
to see Your hand moving powerfully
in the lives of those close to me, and in mine?

I died and was reborn, flesh into Spirit, alive now
How many times have You raised me from the dead
in a miraculous way physically and mentally,
spiritually and emotionally?

This stumbling stone is the latest and freshest in mind
The hardest in some ways, seemingly unending
Critically important for me and those close to me
But You hold me up You keep me on my feet

I give thanks for my church family at Gloria Dei
Today is a Lenten Sunday
My good friend, Pastor Dwight, is giving a message on
Jonah, God's message of rebellion and redemption

I ask myself, am I a Jonah? Rebelling, repenting,
obeying but still having a resentful, unforgiving heart
Not trusting You who are so faithful and loving,
so good and kind, so gracious and true to me

Getting in touch with You and myself,
I walk on the bike trail following
the Big Sioux River downstream
but into strong wind
A few walkers and bicyclists are also enjoying
the fine day and splendor of nature

The slow-moving river is on my right,
golf courses on the left I'm nearing a place
where I can view the house that sits on the bluff
where my family's house once stood,
where my parents lived together for 40 years
It's gone now

Asking you, Lord, where do we go from here?
Be still, know I am

Go Where Glory Calls You

From running in a deadly rut to sailing on the open sea
I have balance now, my life back again,
no longer working myself into an early grave
Thank goodness the good Lord saved me from that

To His everlasting glory, glory unto glory

It's not possible to do the impossible without Him
Nothing is impossible with Him
I got off course somehow
Not knowing, realizing, I kept on going, blindly
Not resting in You, I thought I knew what to do

Do not be wise in your own eyes

My character began to change, how awful, very strange,
looking back on it now I was puffing up with pride,
joining others griping, at superiors sniping,
forgetting we were all on the same side

Pride goeth before destruction,
a haughty spirit before the fall

We have ethical principles that guide my profession
One is non-maleficence
First, do your best to do no harm
Another one is beneficence

Then, do some good if you can
But causing harm is inevitable despite
all the good that physicians do

All have failed and fall short
of the glory of God

Twice You plucked me
from the place I'd lost grace
Still determined to find a similar position,
I searched for months, racked my brain
It seemed like I was losing my mind
Then I stopped, took a step back
I had no reason to despair

Delight in the Lord and He will give you
the desires of your heart

My heart! My first Love!
Trusting in You completely
Surrendering to You, exercising my faith daily
Being a doer and not just a hearer
of the divine, living Word
Jesus, my beloved!
Jesus, I can see again!

Thank you for leading me
to this godly, healing community
where I now serve you
in this lovely and peaceful setting,

never forgetting I live my life for You
and give my life to You
Gracious Lord Jesus, I want to sow
and to grow, so others look at me
and see You

Amen

Two Domains

Call it enjoying the solitary life,
being introverted by nature,
needing refuge, respite from
the hustle and bustle
of the unrelenting times

So easy to rationalize, disguise
what is really going on
Not a healthy thing, this
awful self-absorption,
preferring to stay home

I work in the mental health field,
engage in an intimate way
with people who are strangers
when we first meet,
hurting and vulnerable

I need to connect personally,
establish rapport and trust,
listen and learn their life story
Enough of the story, that is,
to get at the heart of their pain

Then, I offer hope, a plan to help,
address the immediate problems,
find remedies for them

Identify goals for the future
When led, address their final fate

I see possibility in everyone
I see the eyes of my Lord Jesus
looking back at me
I see the least of these
aching to be set free from pain

Yes, the pain has meaning
Yes, the Truth sets you free

Jesus will set you free

Living

Today

War on the plains
in the valley
on the mountains

One day

A plateau of peace
river of love
heaven of glory

Day

With no more pain
no more tears
no more sin

And no end

Praise God!
Worship Him
Bow down to Him

And pray

Anchored to the Rock
Sailing in the Spirit
Guided by the Father

Every day

Crucified with Christ
Alive in Him
Following Him

my Jesus

Amen

I saw a Bald Eagle Today

I was driving north on Interstate 29
between 26th and 12th Street,
following the Big Sioux River

It was flying low and went slowly
in front of me so I got a clear look
It was a thrilling sight,
a spiritual experience
It was like looking at God
I even said, God, You are an eagle
The Creator is surely in His creation

He is the eagle, the air flowing
over outstretched wings,
the gray clouds hiding a cold sun,
the heart beating within me,
the spirit of peace and joy
lifting me high until I, too, am soaring,
alive and skimming the sky

Finally free from the gravity of earth
and life below, I sail toward the heavenly goal
where I will cross the River Jordan

I am a bald eagle today

Part 6
Celebrating

A Thanksgiving Prayer for Christmas

Dear Heavenly Father,
we are to give thanks in everything,
the highs and the lows, good times and not so good,
the triumphs and the trials because You are with us
You know what is best for us
Your love is fathomless
Your goodness and mercy endure forever and
all Your promises are trustworthy and true...

With You, Lord,
we may have joy in every circumstance
for Your joy is our strength,
it comes with each new day
You give us the peace that surpasses understanding,
peace the world cannot give, peace not of this world
from the Prince of Peace, bright Morning Star, Savior,
Redeemer, King of Angels, Lord God Almighty...

With You in us, Lord, we are Your body, Your temple,
each of us a living stone in the Kingdom we build
together
You are the Cornerstone and the Capstone, Master
Designer, Creator, Craftsman, Overseer, Builder
You are our all in all, every good gift is from You
We bow down to You and offer our lives to You...

We are thankful every day, but especially today
We remember and are mindful of what we have
How blessed we are in the here and now
to have warmth in the cold, a roof over us,
our families gathered together with no need
to be anxious for clothes to wear, food to eat...

We thank You, Lord We praise You, Lord
We exalt You, Lord, and lift up Your holy name,
the name above all other names,
the name by which we must be saved
Jesus Christ, Yeshua, Immanuel
and in Your name we pray Amen

Merry Christmas, and may
God bless us, every one!

in His love,
Bob Giebink

A Christmas Greeting

It's the season of hope, you know,
and of expectation,
of joy and celebration,
of peace on earth and
good will toward men (and women)
from God our Father in heaven,
who reached down and touched us
in perfect love with His son,
the baby Lord Jesus,
born in a manger in Bethlehem town
of Mary, a virgin

Go, tell it on the mountain,
over the hills, and everywhere
Go, tell it on the mountain
Jesus Christ is born

It's Christmastime!

Bing sings, It's the most wonderful
 time of the year
Jimmy Stewart discovers he truly has
 a wonderful life
Natalie Wood wishes, believes, gets
 her miracle on 34th Street
Jesus Christ, King of Angels, steps
 down from heaven
Son of God, now Son of Man, is born
 Immanuel
Light of the World shines brightly over
 all the earth
Our Divine Deliverer is alive and
 reigns on high
Creator of the universe invites you
 to join Him
You are welcome to feast at His
 wedding table
Receive a new body, a new song,
 a new name
Rejoice with all the saints and shout
 Hallelujah!

always in His love,
 Bob Giebink

Epiphany

Born baby Jesus in humble manger,
promised Prince of Peace, Lord and Savior

See star atop bright Christmas tree
Contrast cross at dark Calvary

Bright Morning Star, Everlasting Light
for our sins Christ suffered and died

Him we seek this Noel season
In Him find life, the truth, the reason

All hope we await finish of story,
King of Angels, God of Glory

Now store treasures in Heaven above
Crowns to cast down with infinite love

When we meet face to face
Kneel at feet of Perfect Grace

Sundog Day

It is 6 below in Watertown,
11 below in Aberdeen, the air is still

The sun is brilliant in the east,
two gloved fingers above horizon

Beneath it, frozen prairie landscape
and a fresh dusting of snow

In the west, a three-quarters moon
two gloved hands above horizon

All around is the wintry blue sky
It forms a heavenly dome

On either side of the sun, a rainbow
sundog rising up, giving praise

Me, too, as I join in praise with them,
my own ode to joy on my way to work

Winter solstice soon, Christmas, too
Celebrating our Lord's first coming

Bright Morning Star, Light of the World
Baby in a manger Hallelujah!

Restored

Lord! What is happening?
It's Holy Week, Passover
First, Palm Sunday arrived
I lifted, waved a palm branch,
shouted, Hosanna! Exalted You
Bowed down, spread my garment
on the ground to settle the dust
Watched my King ride by

It was as if the rocks
were crying out, Behold!

It's Maundy Thursday now
Here You are washing my feet,
showing me how so I may follow
and wash the feet of others
Poor Peter! the exuberant one
Yes, Peter, you are all clean
No, Peter, you cannot go where
I go, for it is not your time

It is mine It is my sorrow and
my joy to pour myself out

Good Friday, it surely is
Very good for lost souls,
the spiritually fallen,

living in a darkened world
under rule of fallen angel
Once named bearer of light
now Adversary, Enemy
seeking only to kill, destroy

But You are the Pure light,
the Way, the Truth, the Life

Oh, what a brilliant morn',
breaking like the first day
The stone is rolled away
The tomb is empty, cold
Mary's grief is great
"Woman, why are you crying?
Who is it you are looking for?"
You spoke her name, "Mary"

Grief turned to great joy
She cried out, "Teacher!"

The Lord is risen
He is risen indeed

Amen

The Mercy Seat

I saw it! Dear Lord, I saw it

Today, this morning, driving to work
Outside it's 11 below zero,
northwest wind blowing,
sweeping fine snow into the air

I saw it! Praise God, I saw it

A double set of bows rising skyward,
higher and higher like outstretched arms,
the inner set completing its arc
above a brilliant sun hanging at the center

Oh, glorious sundog day!

Sitting atop the outer rainbow arc
is a smaller arc, this one concave
and forming a glowing, golden bowl,
a celestial seat Could it be?

Glory be! It's the mercy seat
I saw it! Thank you, Jesus, I saw it

Today, a visual reality
A vision of eternity
A glimpse of heaven

A powerful sign, a sure promise
Clear as can be
You are near You are coming
You are mine

I see you! Dear Lord, I see you

Part 7
A Warning

The Hidden Army

A global army of soldiers battling in plain view,
yet somehow all but invisible in a world teeming
with brave souls searching for refuge
from the madmen who target them in quest
of power and self-glory, spurning peace

The traffic on Jacob's ladder is especially heavy
these days, special Agents ministering to those
who minister to save the victims of war,
those who are suffering, dying
and those surviving, living in terror

Forces range from Most High in rank, directing
campaign from central headquarters,
to the most exposed on the frontline where service
includes willingness to die without ever firing a shot
or engaging in violence of any kind

It's an army of soldiers commanded by a Prince,
the Prince of Peace, Light bringing Light
Truth revealing Truth, the Way making the Way
Victory assured but the war rages on

Knowing the Prince of Peace has already won,
the prince of darkness roars in defiance,
raging at his doom It's only a matter of time
before the Prince returns as Mighty King

He arrives in all Glory and Power, and with Him,
a Heavenly Host of fearful Combatants
All the world will see Him coming in a cloud,
Standing on the Mount, our Lord and Leader

"Behold, I am coming soon! My reward is with me
and I will give to everyone according to what
he has done I am the Alpha and Omega,
the First and the Last, the Beginning and the End

Blessed are those who wash their robes
that they may have the right to the tree of life
and may go through the gates of the city

Outside are the dogs, those who practice
magic arts, the sexually immoral,
the murderers, the idolators, and
everyone who loves and practices falsehood

I, Jesus, have sent my angel
to give you this testimony
for the churches

I am the Root
and Offspring of David,
and the bright Morning Star…"

"Yes, I am coming soon."

"Yes, I am coming soon."
Revelation 22:12-21 NIV

12 "Look, I am coming soon! My reward is with me, and I will give to each person according to what they have done.

13 I am the Alpha and the Omega, the First and the Last, the Beginning and the End.

14 "Blessed are those who wash their robes, that they may have the right to the tree of life and may go through the gates into the city.

15 Outside are the dogs, those who practice magic arts, the sexually immoral, the murderers, the idolaters and everyone who loves and practices falsehood.

16 "I, Jesus, have sent my angel to give you this testimony for the churches. I am the Root and the Offspring of David, and the bright Morning Star."

17 The Spirit and the bride say, "Come!" And let the one who hears say, "Come!" Let the one who is thirsty come; and let the one who wishes take the free gift of the water of life.

18 I warn everyone who hears the words of the prophecy of this scroll: If anyone adds anything to them, God will add to that person the plagues described in this scroll.

19 And if anyone takes words away from this scroll of prophecy, God will take away from that person any share in the tree of life and in the Holy City, which are described in this scroll.

20 He who testifies to these things says, "Yes, I am coming soon."

Amen. Come, Lord Jesus.

21 The grace of the Lord Jesus be with God's people. Amen.

Given to the Apostle John on the island of Patmos

Part 8
Salvation

Jesus Saves Sinners

Dear Jesus, I have lost my way
I am a sinner, and I am powerless over my sin
I need your help
Please forgive me all my sins
I believe you lived a sinless life
and died on the cross
to take the punishment for my sin
On the third day, you rose again
to free me from my sin
and to open the way to your Father in heaven
Lord Jesus, I want to love you with all my heart,
serve you with joy and follow you unto life everlasting

Amen

Peter Addresses the Crowd

Acts 2:14-21 NIV

14 Then Peter stood up with the Eleven, raised his voice and addressed the crowd: "Fellow Jews and all of you who live in Jerusalem, let me explain this to you; listen carefully to what I say.

15 These people are not drunk, as you suppose. It's only nine in the morning!

16 No, this is what was spoken by the prophet Joel:

17 "'In the last days, God says, I will pour out my Spirit on all people.

Your sons and daughters will prophesy, your young men will see visions, your old men will dream dreams.

18 Even on my servants, both men and women, I will pour out my Spirit in those days, and they will prophesy.

19 I will show wonders in the heavens above and signs on the earth below, blood and fire and billows of smoke.

20 The sun will be turned to darkness and the moon to blood before the coming of the great and glorious day of the Lord.

21 And everyone who calls
on the name of the Lord will be saved." Amen

About Kharis Publishing:

Kharis Publishing, an imprint of Kharis Media LLC, is a leading Christian and inspirational book publisher based in Aurora, Chicago metropolitan area, Illinois. Kharis' dual mission is to give voice to under-represented writers (including women and first-time authors) and equip orphans in developing countries with literacy tools. That is why, for each book sold, the publisher channels some of the proceeds into providing books and computers for orphanages in developing countries so that these kids may learn to read, dream, and grow. For a limited time, Kharis Publishing is accepting unsolicited queries for nonfiction (Christian, self-help, memoirs, business, health and wellness) from qualified leaders, professionals, pastors, and ministers. Learn more at: https://kharispublishing.com/

9 781637 462041